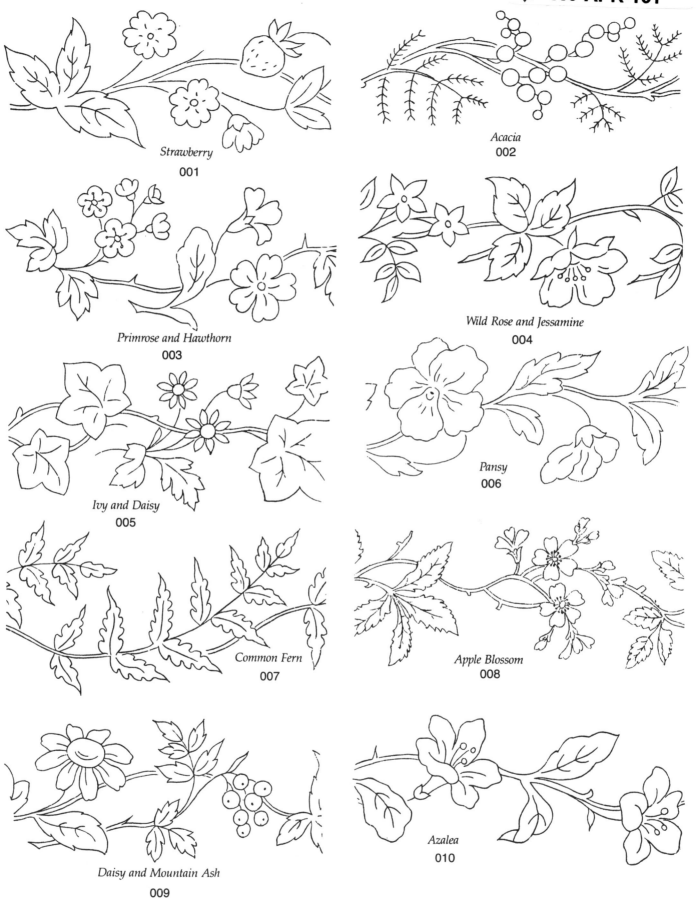

Strawberry
001

Acacia
002

Primrose and Hawthorn
003

Wild Rose and Jessamine
004

Ivy and Daisy
005

Pansy
006

Common Fern
007

Apple Blossom
008

Daisy and Mountain Ash
009

Azalea
010

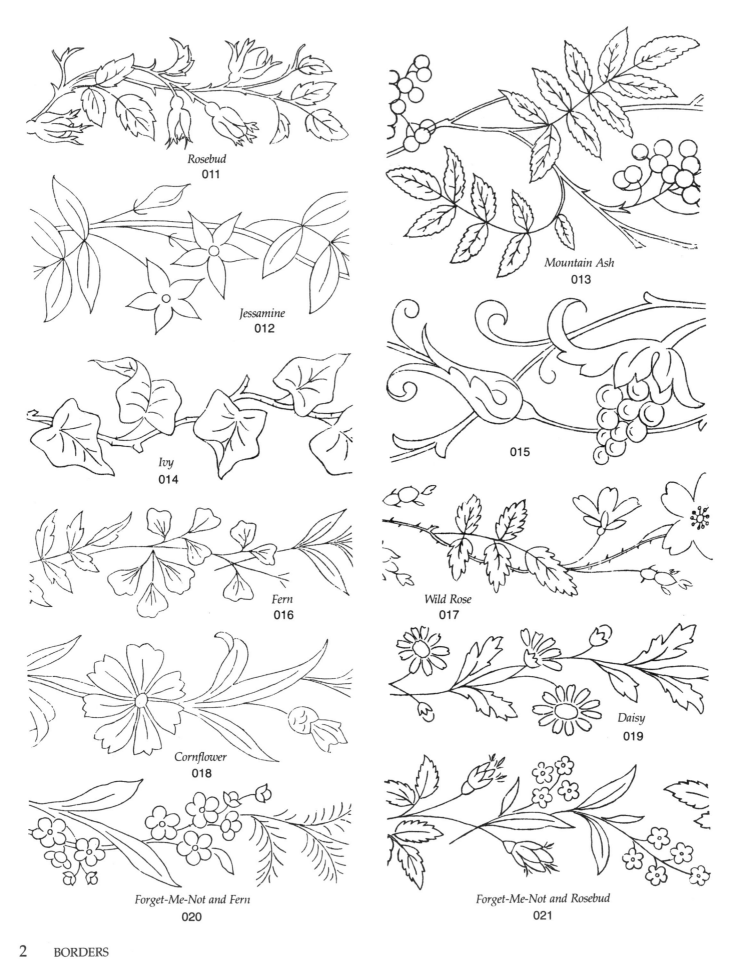

Rosebud
011

Jessamine
012

Mountain Ash
013

Ivy
014

015

Fern
016

Wild Rose
017

Cornflower
018

Daisy
019

Forget-Me-Not and Fern
020

Forget-Me-Not and Rosebud
021

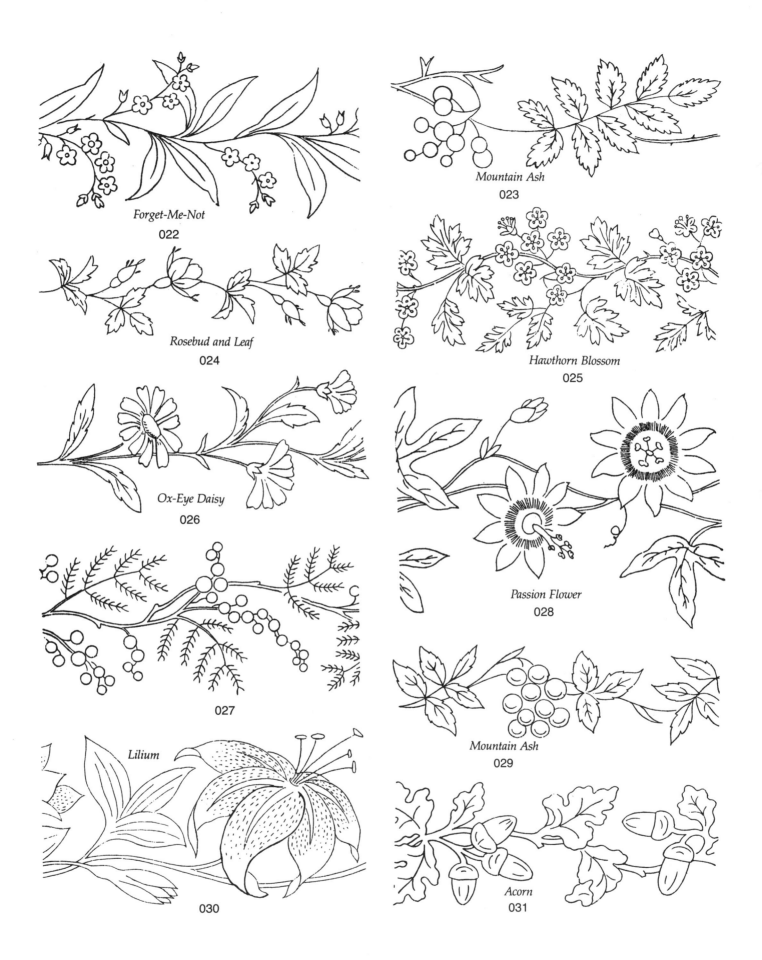

Forget-Me-Not
022

Mountain Ash
023

Rosebud and Leaf
024

Hawthorn Blossom
025

Ox-Eye Daisy
026

027

Passion Flower
028

Mountain Ash
029

Lilium
030

Acorn
031

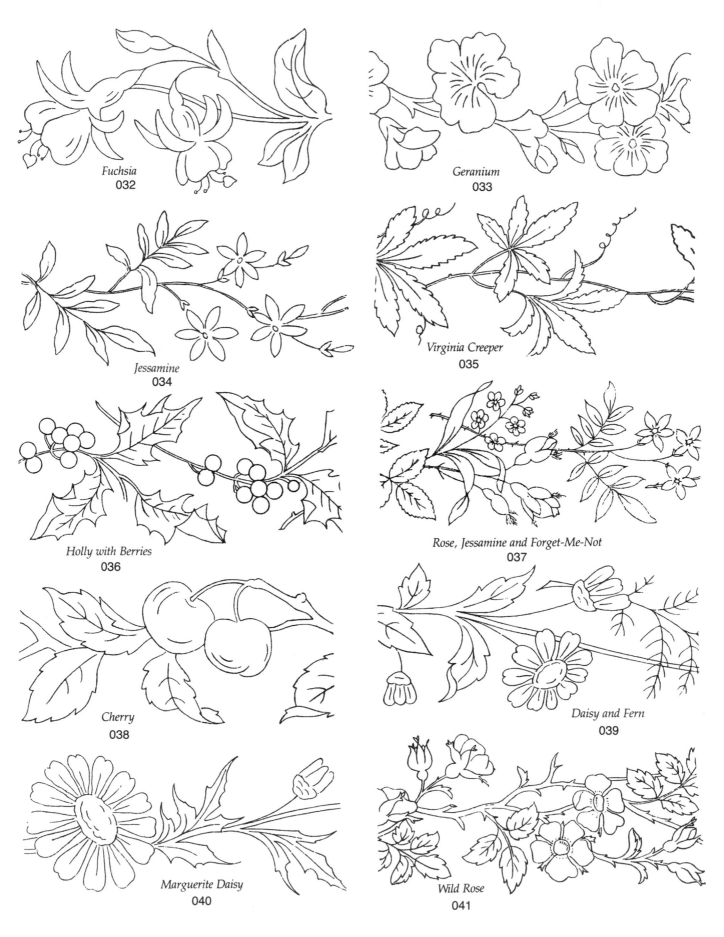

*Fuchsia*
032

*Geranium*
033

*Jessamine*
034

*Virginia Creeper*
035

*Holly with Berries*
036

*Rose, Jessamine and Forget-Me-Not*
037

*Cherry*
038

*Daisy and Fern*
039

*Marguerite Daisy*
040

*Wild Rose*
041

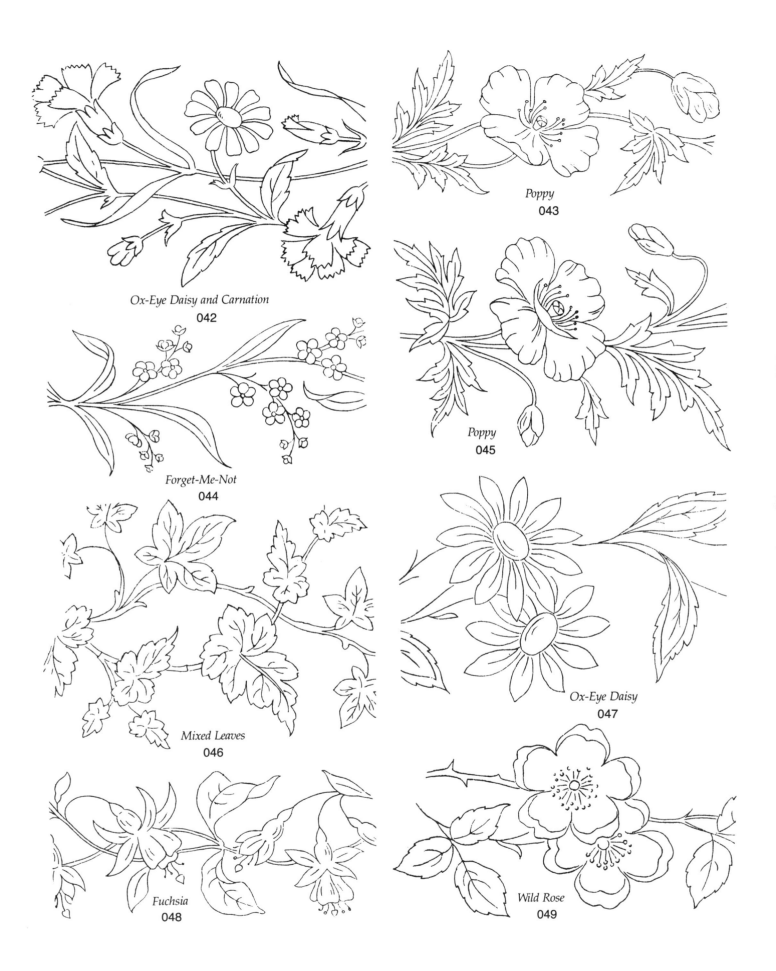

Ox-Eye Daisy and Carnation
042

Poppy
043

Forget-Me-Not
044

Poppy
045

Mixed Leaves
046

Ox-Eye Daisy
047

Fuchsia
048

Wild Rose
049

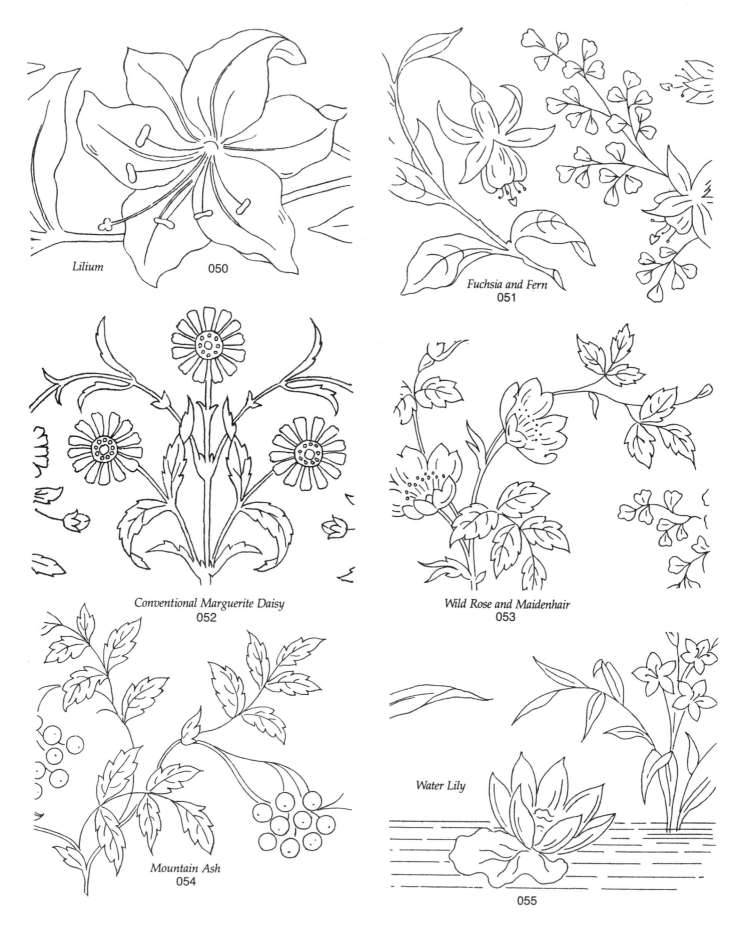

Lilium 050

Fuchsia and Fern
051

Conventional Marguerite Daisy
052

Wild Rose and Maidenhair
053

Mountain Ash
054

Water Lily

055

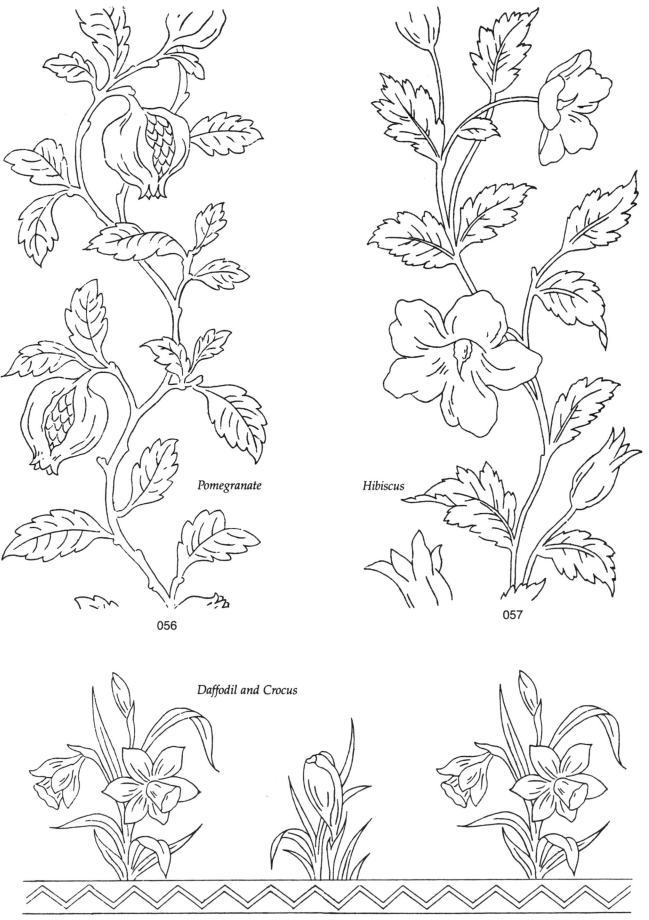

*Pomegranate*

*Hibiscus*

*Daffodil and Crocus*

056

057

058

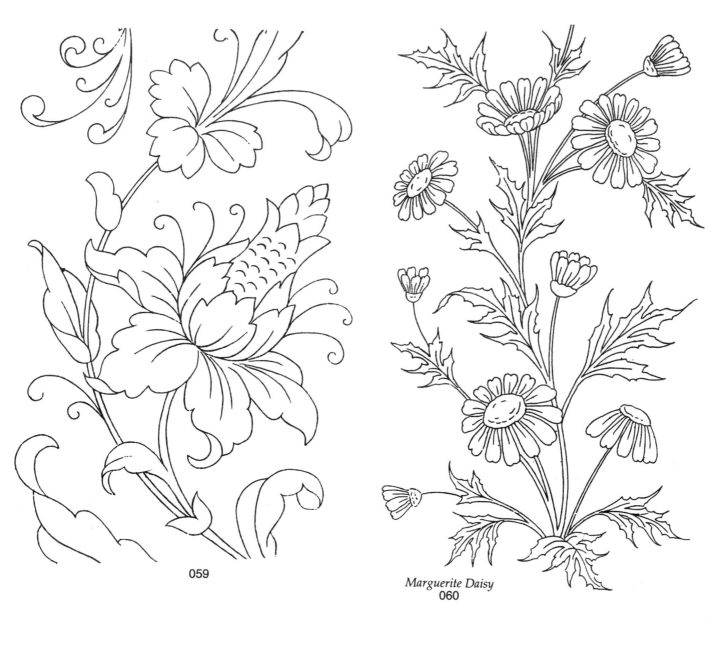

059

*Marguerite Daisy*
060

*Conventional Rose*

061

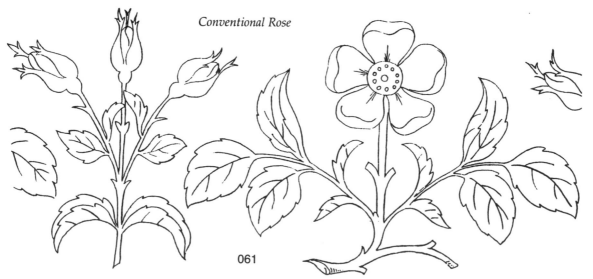

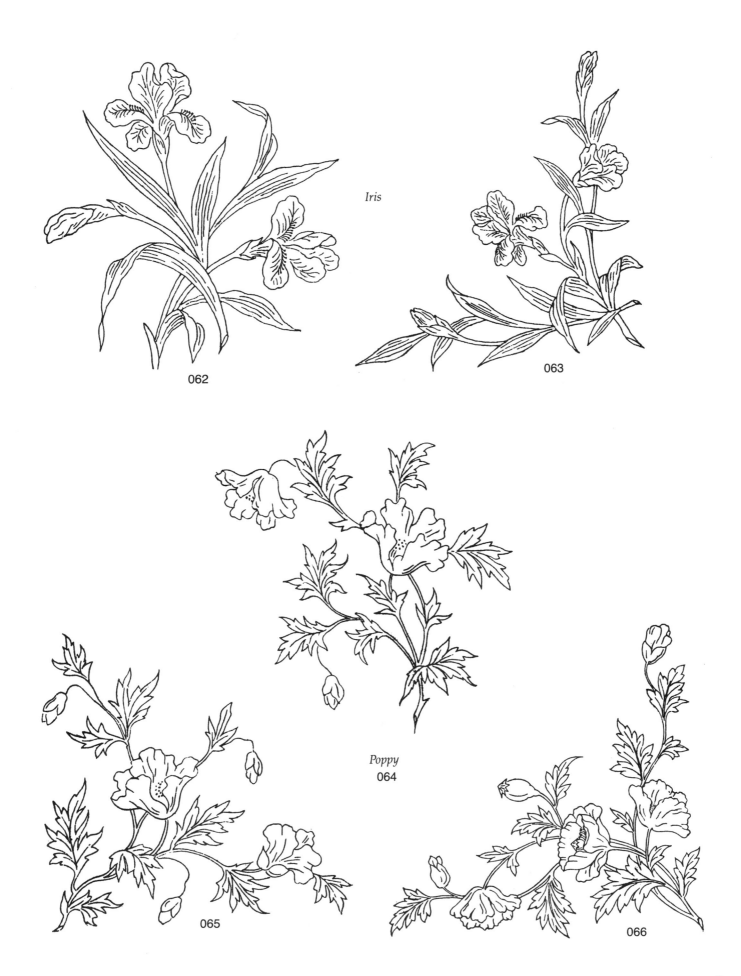

*Iris*

062

063

*Poppy*
064

065

066

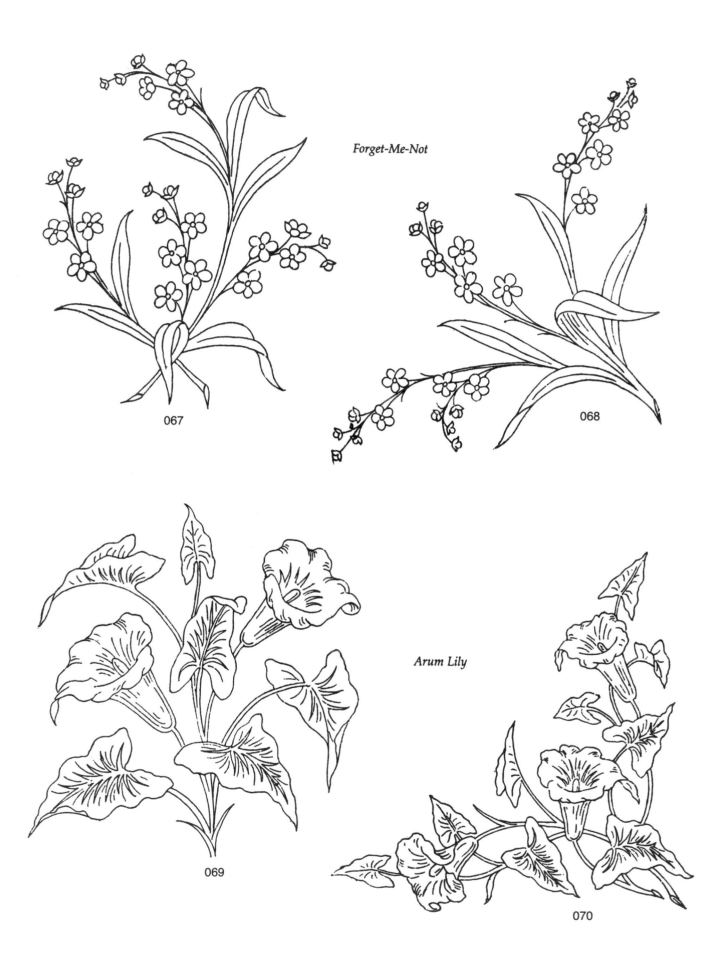

*Forget-Me-Not*

067

068

*Arum Lily*

069

070

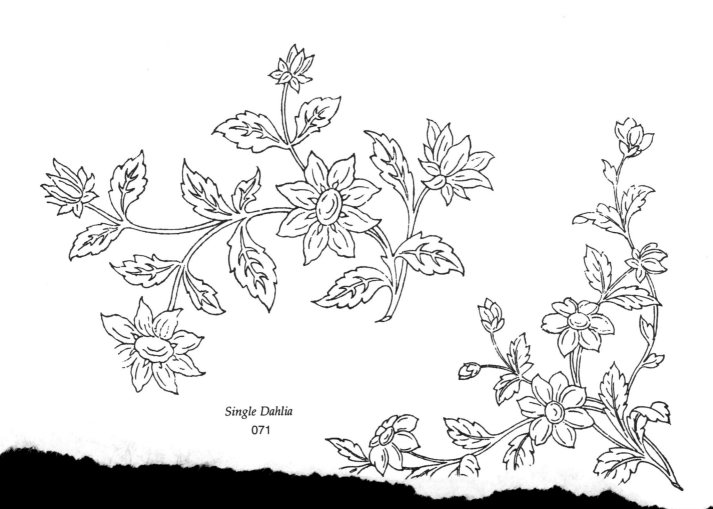

*Single Dahlia*
071

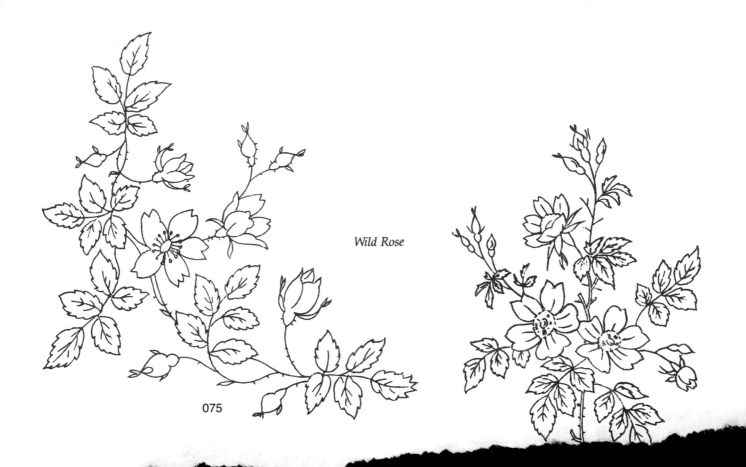

Wild Rose

075

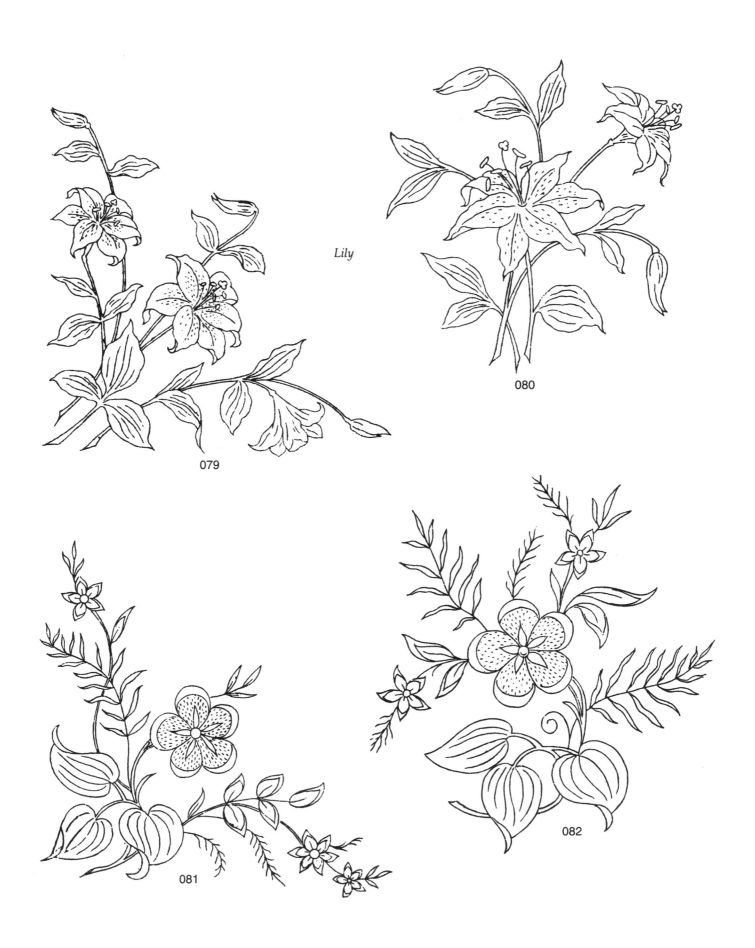

*Lily*

080

079

081

082

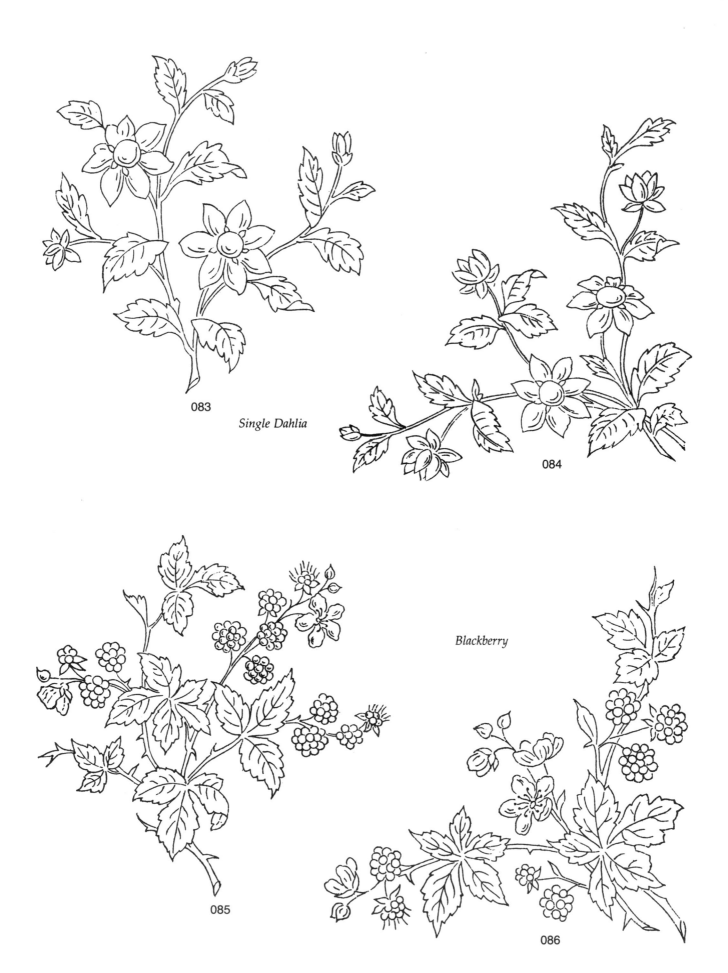

083

*Single Dahlia*

084

*Blackberry*

085

086

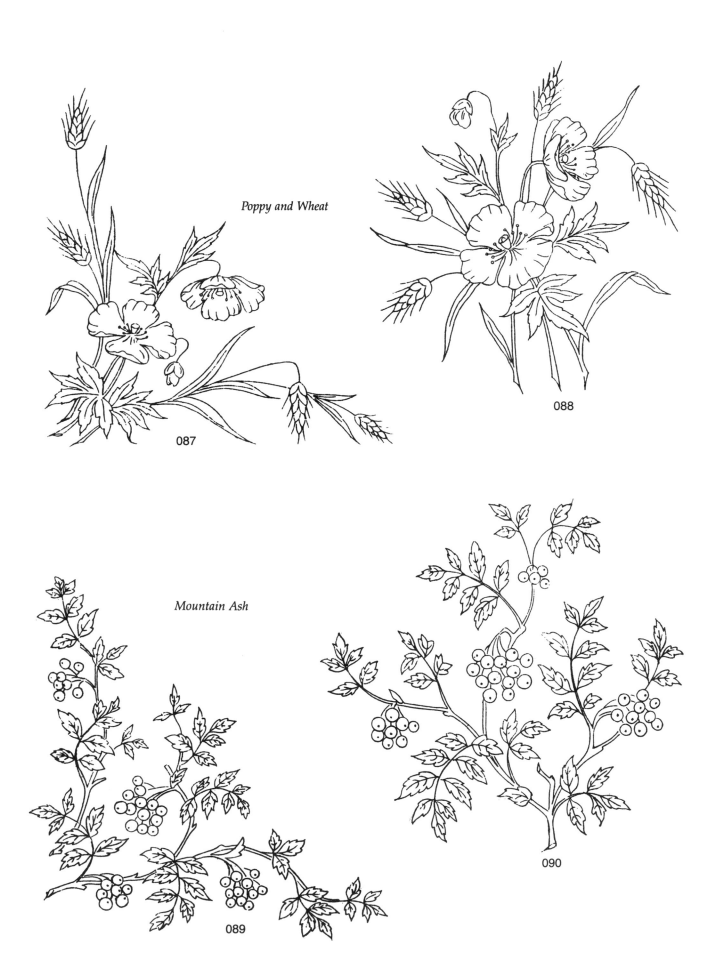

*Poppy and Wheat*

087

088

*Mountain Ash*

089

090

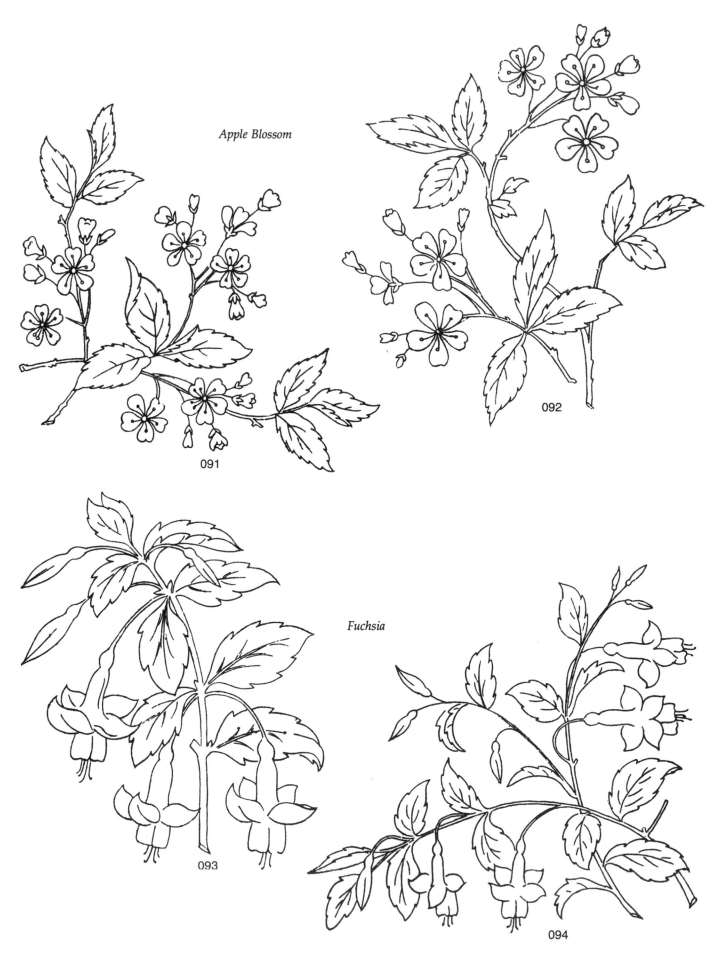

*Apple Blossom*

091

092

*Fuchsia*

093

094

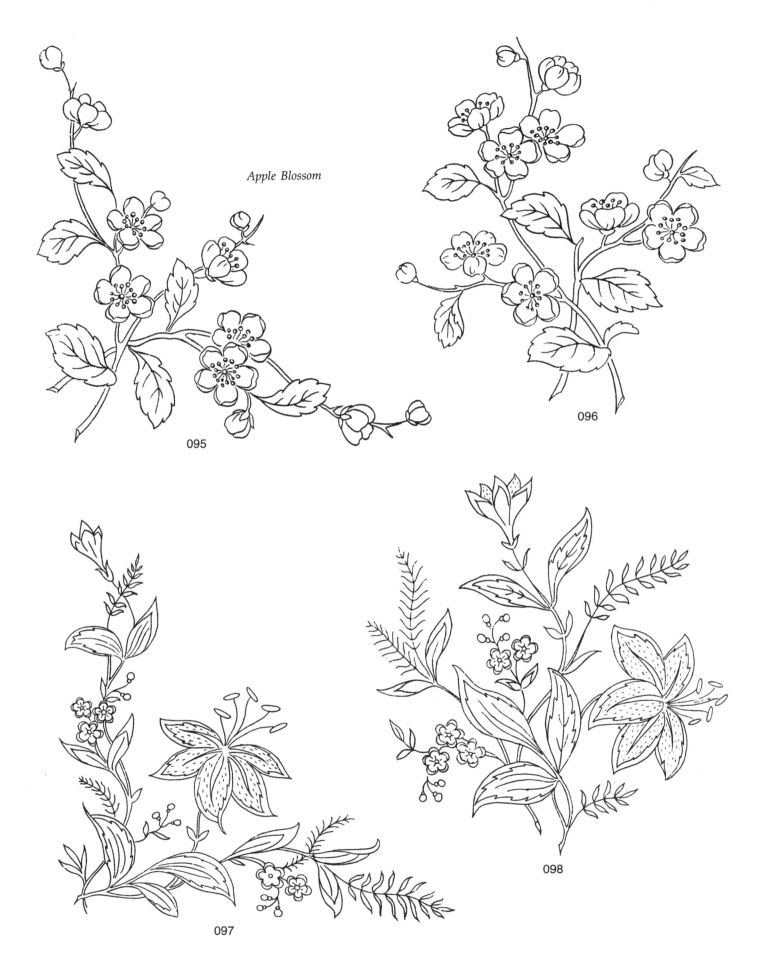

*Apple Blossom*

095

096

097

098

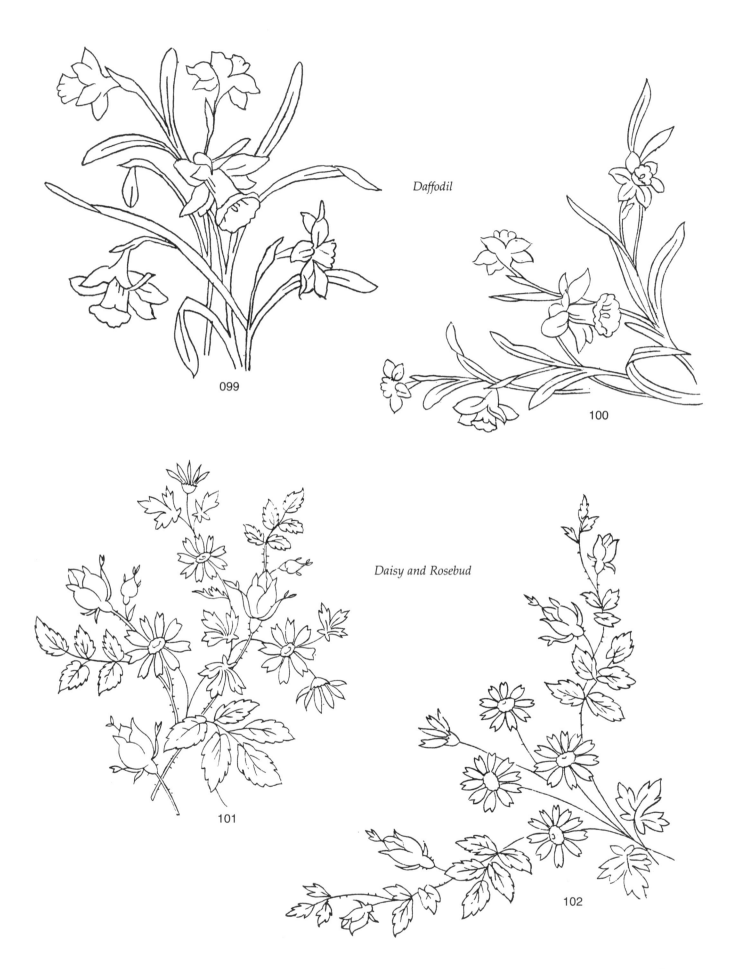

*Daffodil*

099

100

*Daisy and Rosebud*

101

102

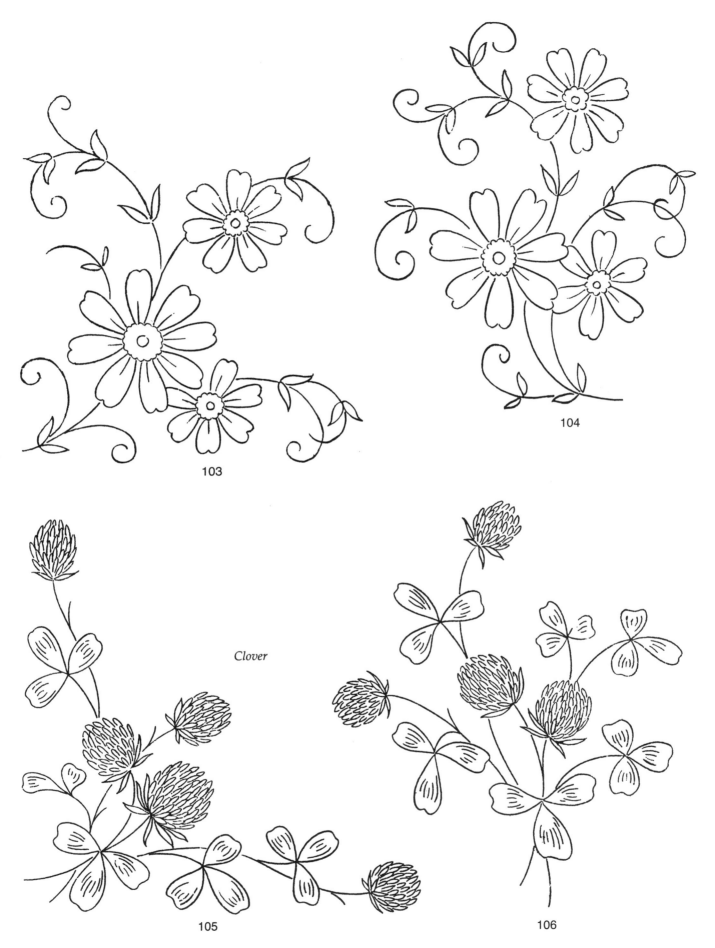

103

104

*Clover*

105

106

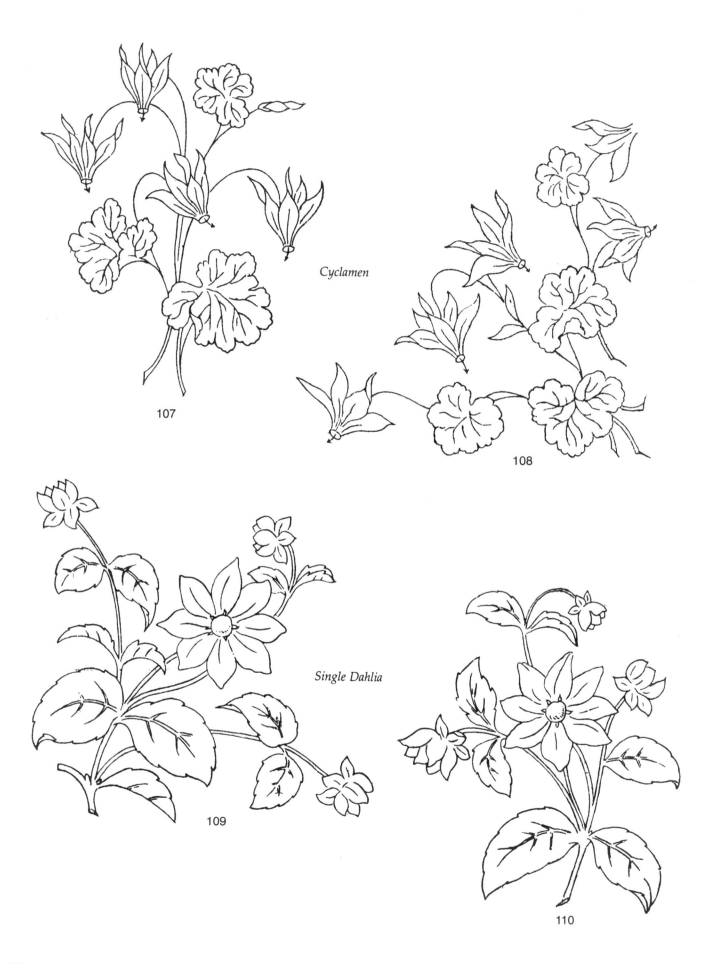

Cyclamen

107

108

Single Dahlia

109

110

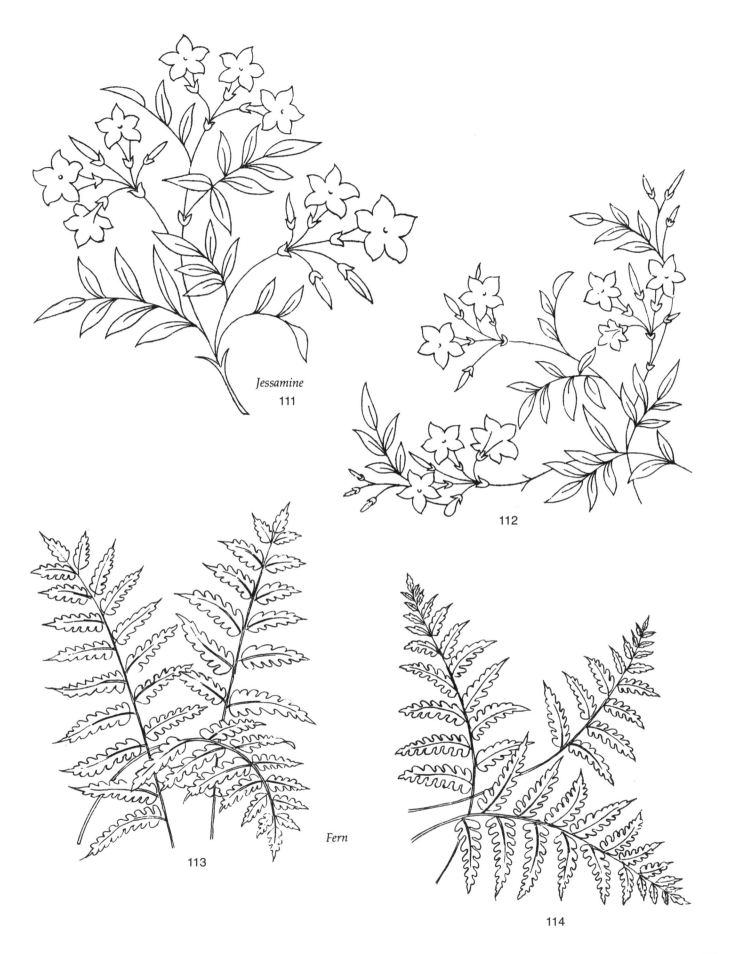

*Jessamine*
111

112

*Fern*
113

114

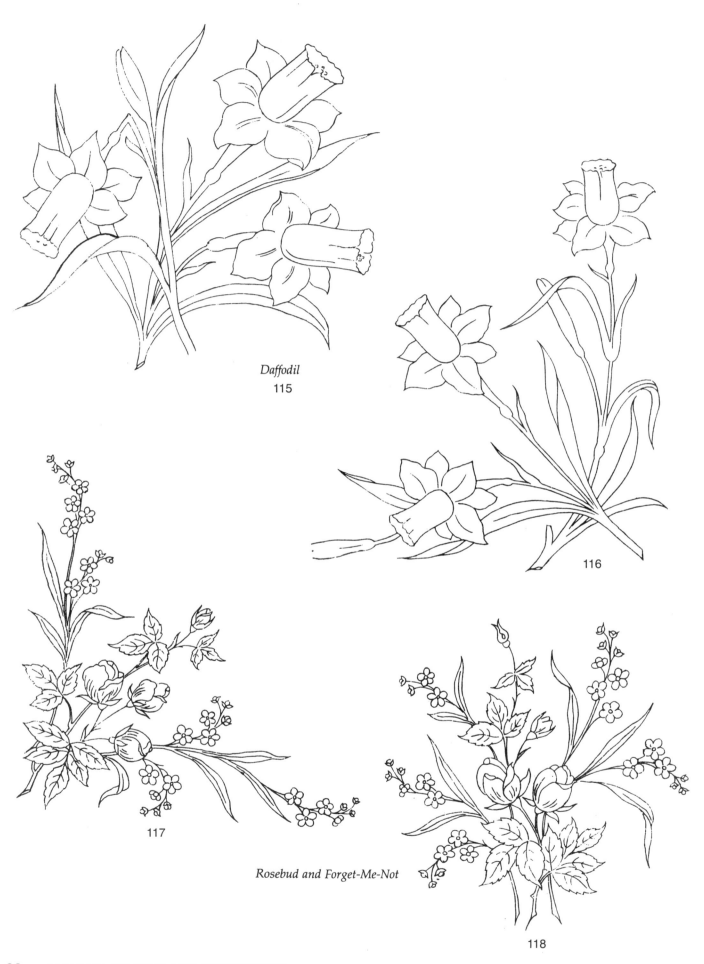

*Daffodil*
115

116

117

*Rosebud and Forget-Me-Not*

118

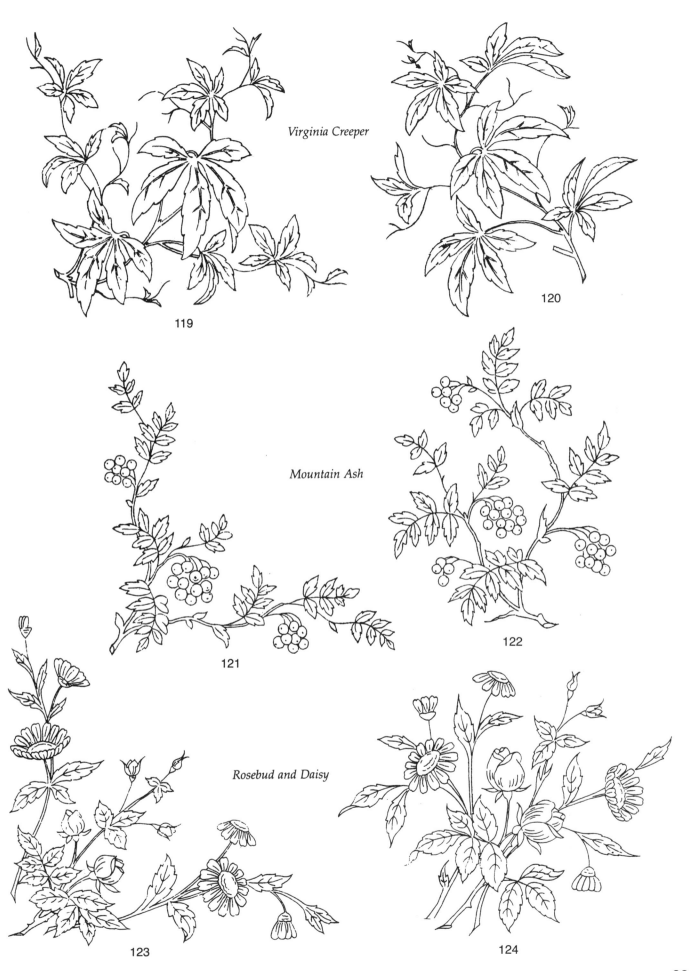

*Virginia Creeper*

119

120

*Mountain Ash*

121

122

*Rosebud and Daisy*

123

124

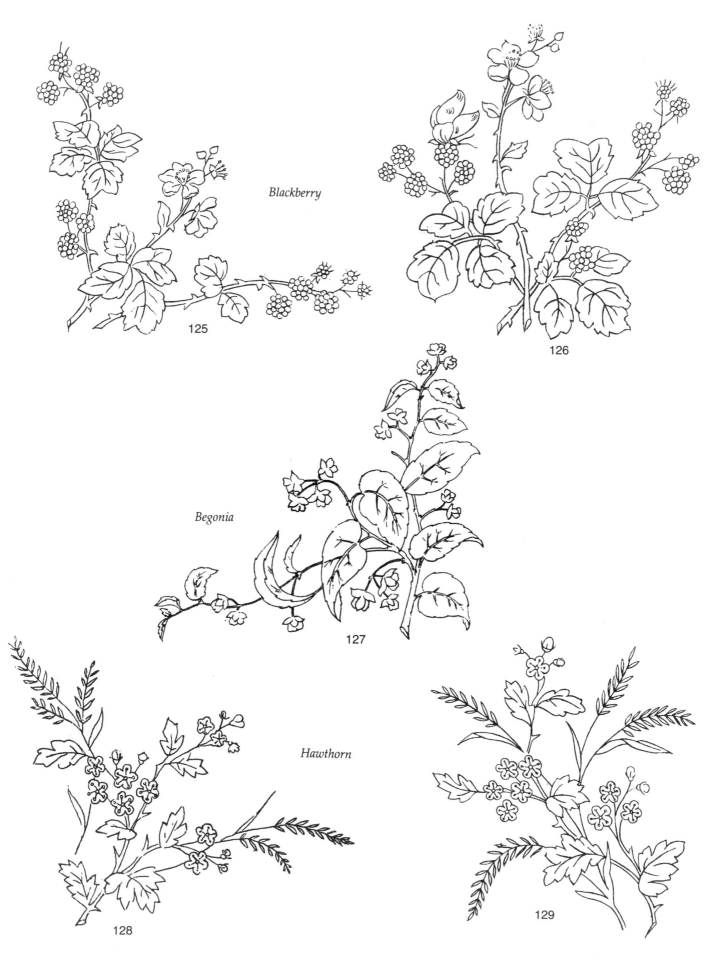

*Blackberry*

125

126

*Begonia*

127

*Hawthorn*

128

129

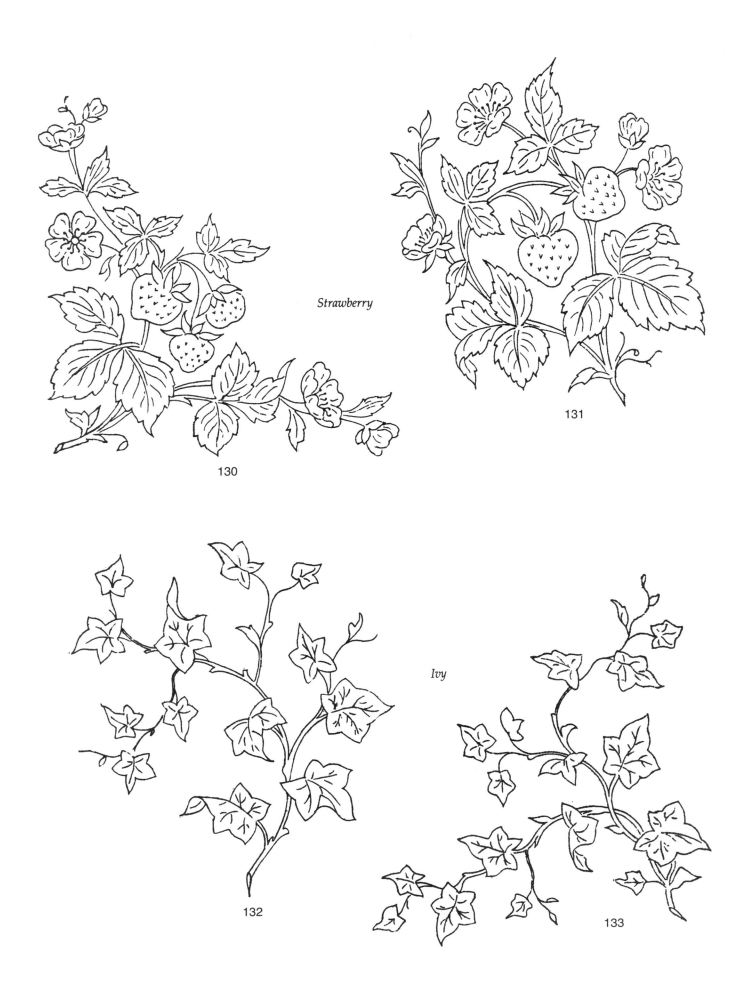

*Strawberry*

130

131

*Ivy*

132

133

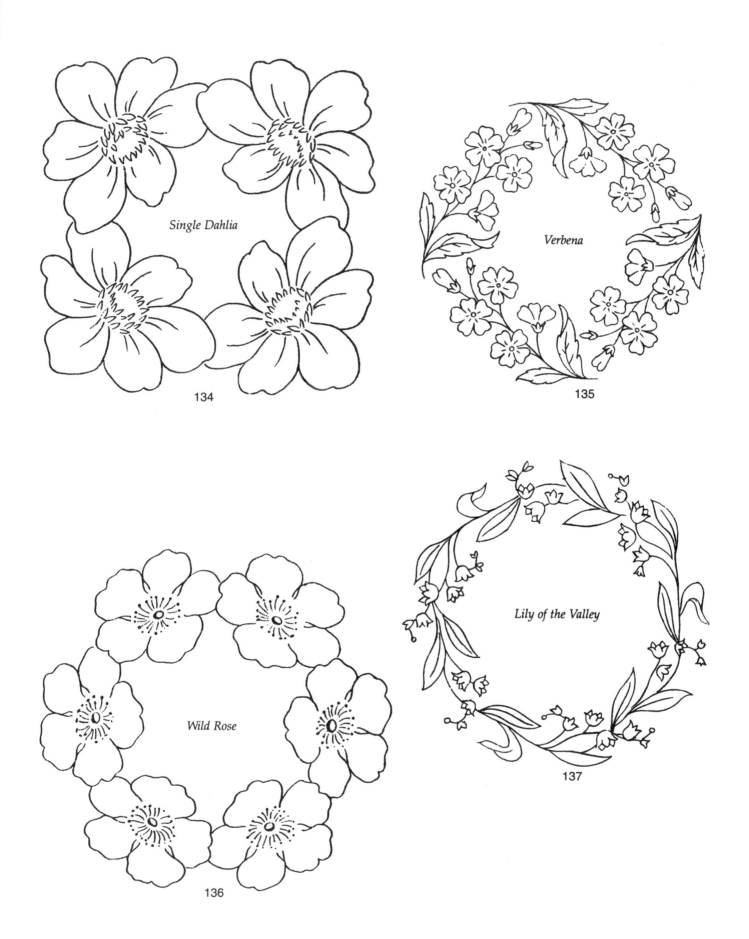

Single Dahlia

134

Verbena

135

Wild Rose

136

Lily of the Valley

137

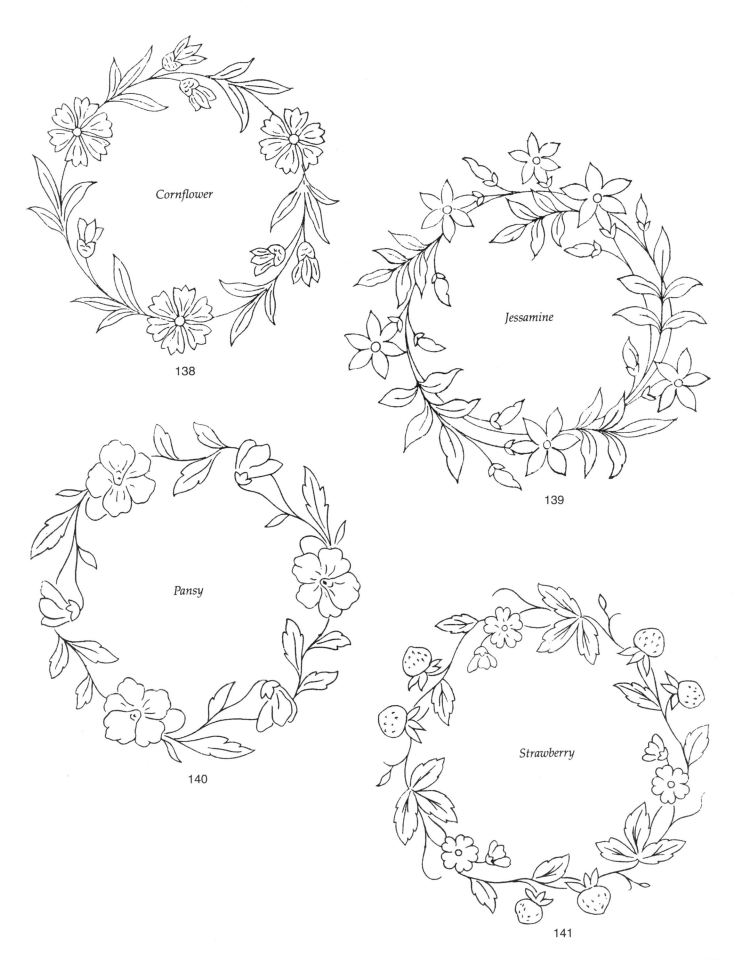

Cornflower

138

Jessamine

139

Pansy

140

Strawberry

141

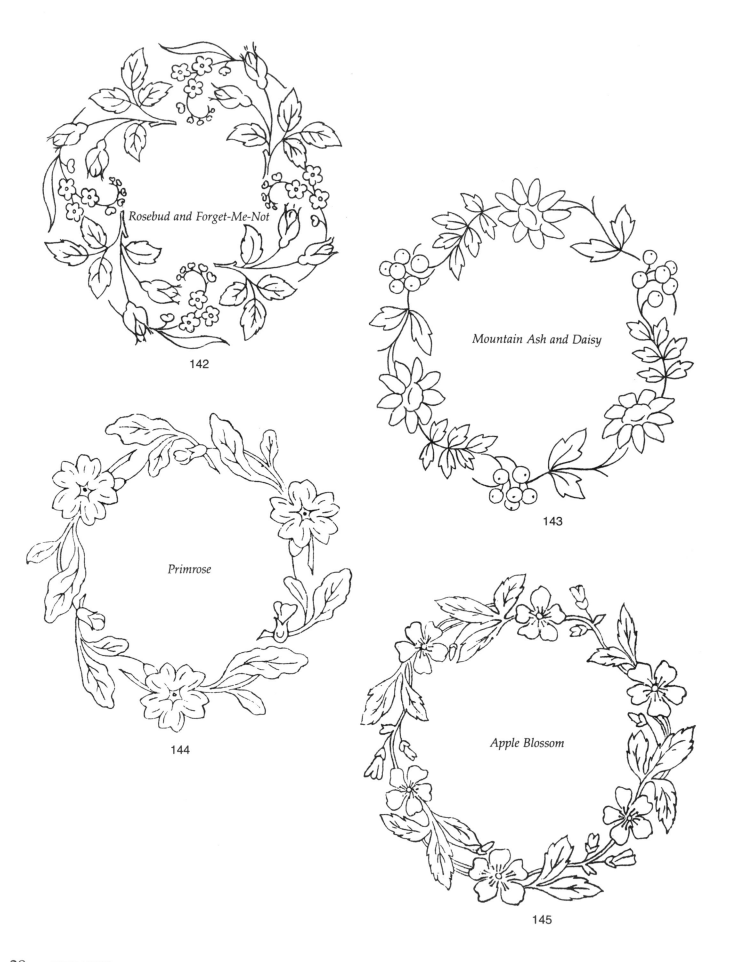

Rosebud and Forget-Me-Not

142

Mountain Ash and Daisy

143

Primrose

144

Apple Blossom

145

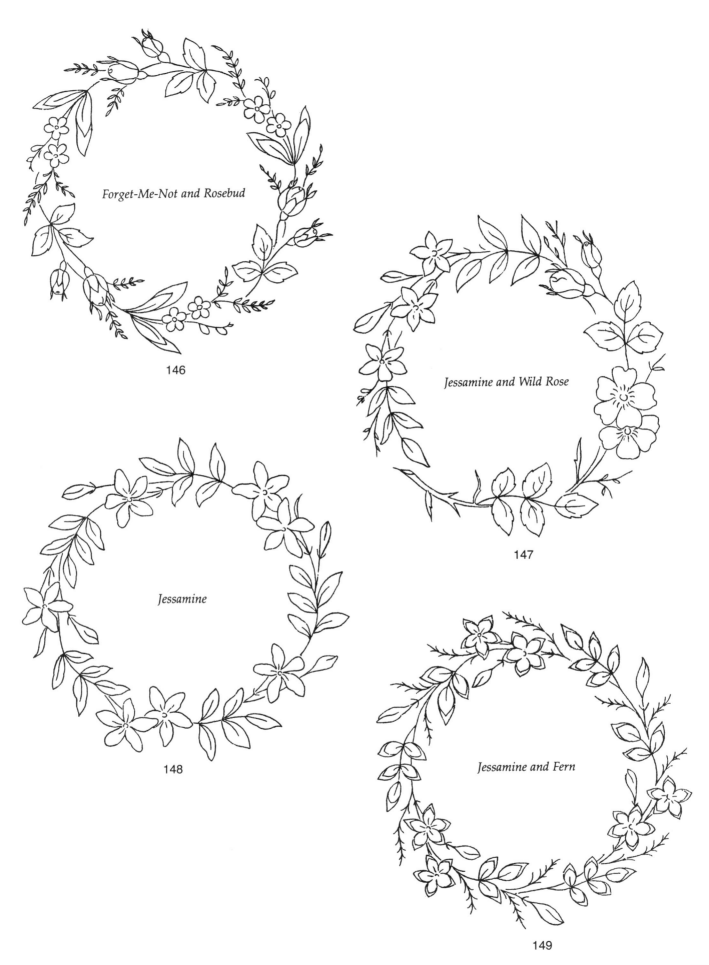

Forget-Me-Not and Rosebud

146

Jessamine and Wild Rose

147

Jessamine

148

Jessamine and Fern

149

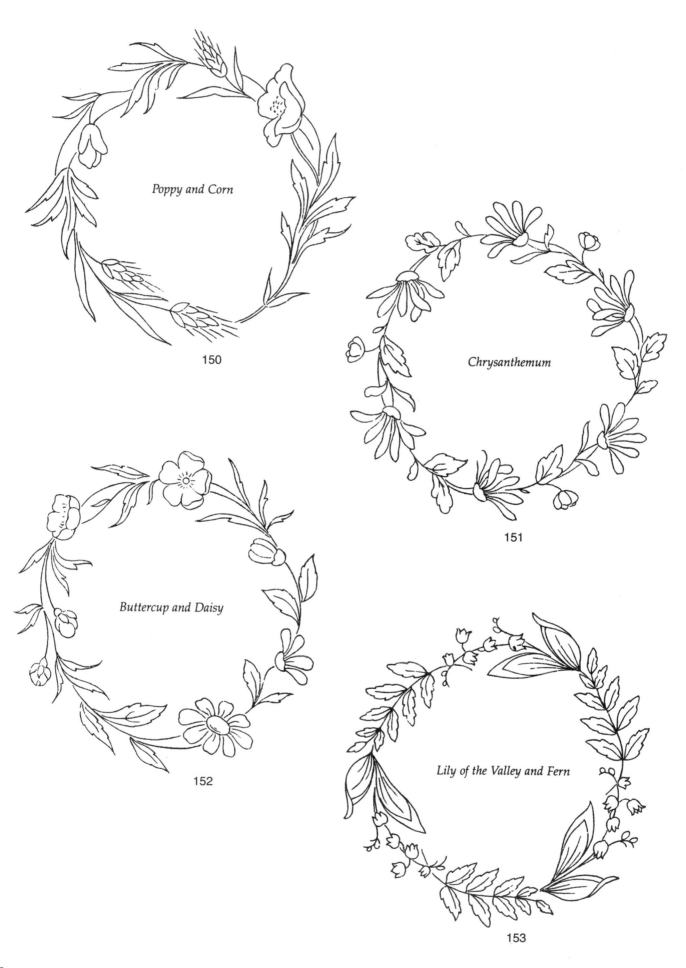

Poppy and Corn

150

Chrysanthemum

151

Buttercup and Daisy

152

Lily of the Valley and Fern

153

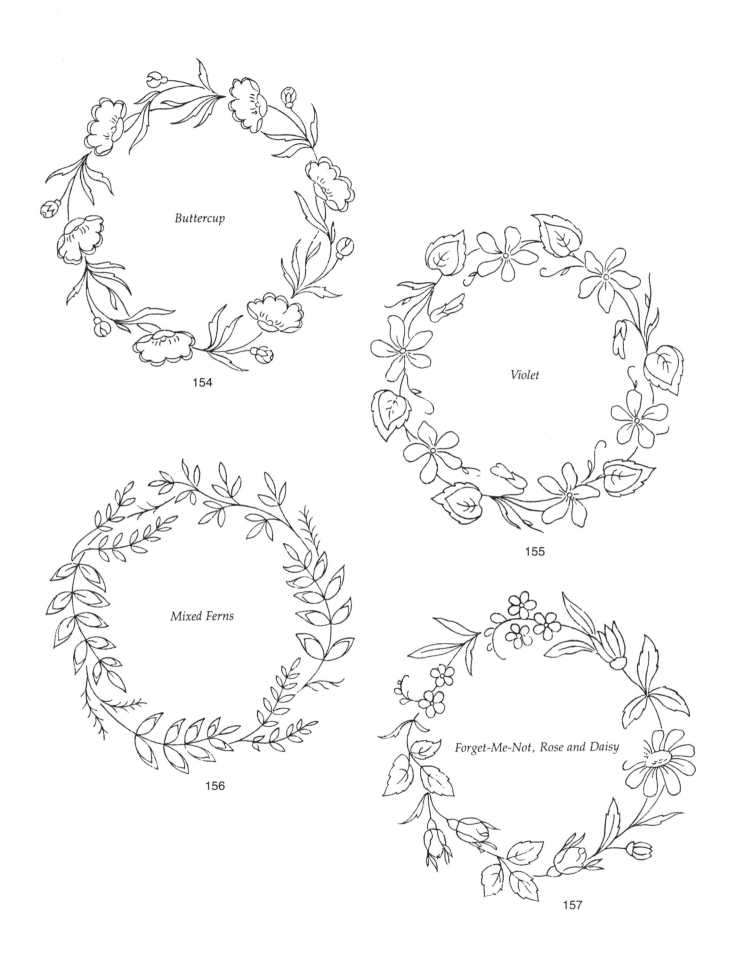

*Buttercup*

154

*Violet*

155

*Mixed Ferns*

156

*Forget-Me-Not, Rose and Daisy*

157

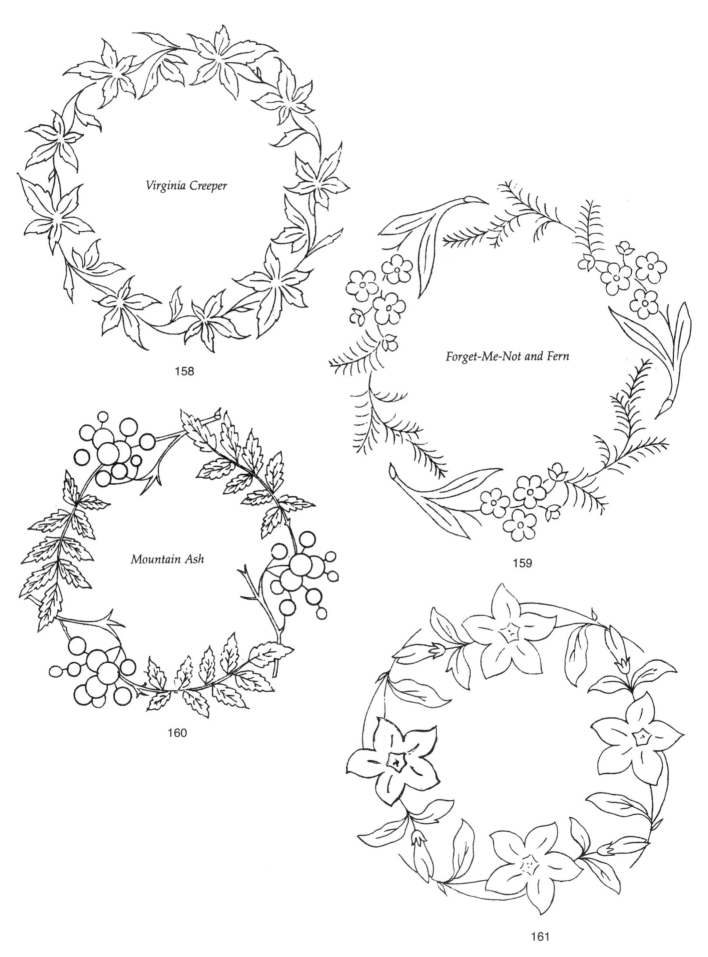

*Virginia Creeper*

158

*Forget-Me-Not and Fern*

159

*Mountain Ash*

160

161

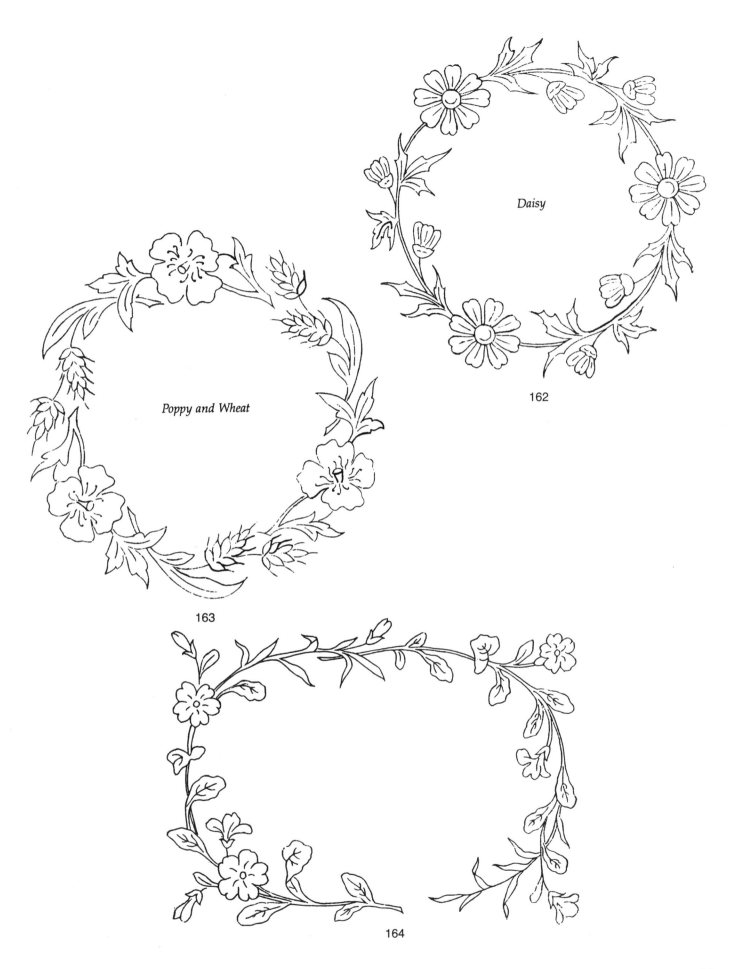

*Daisy*

162

*Poppy and Wheat*

163

164

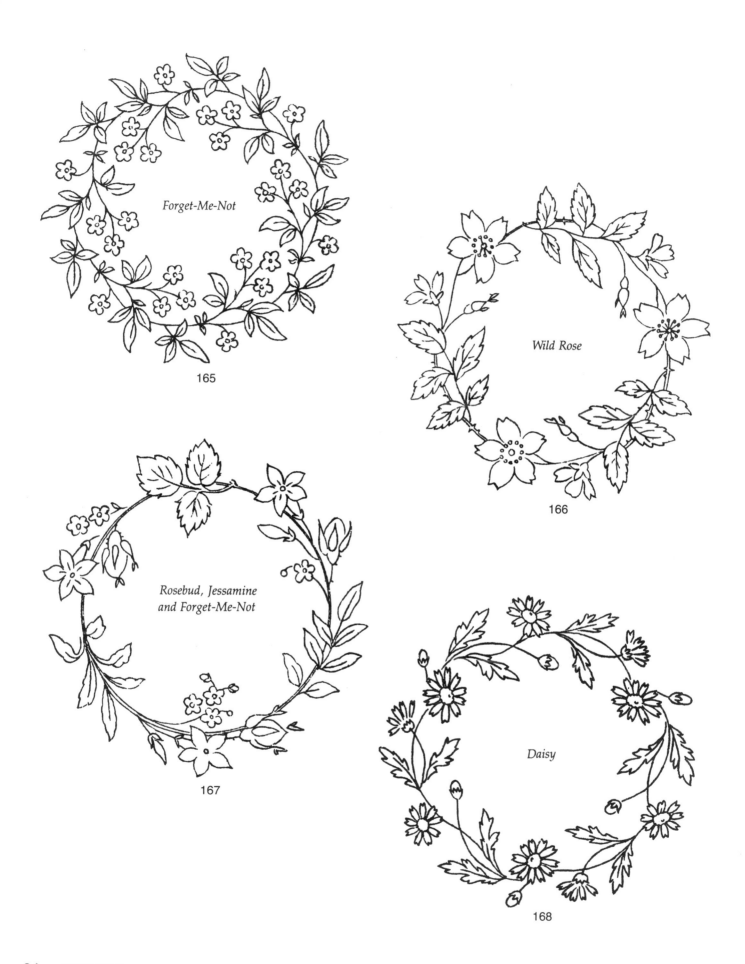

*Forget-Me-Not*

165

*Wild Rose*

166

*Rosebud, Jessamine
and Forget-Me-Not*

167

*Daisy*

168

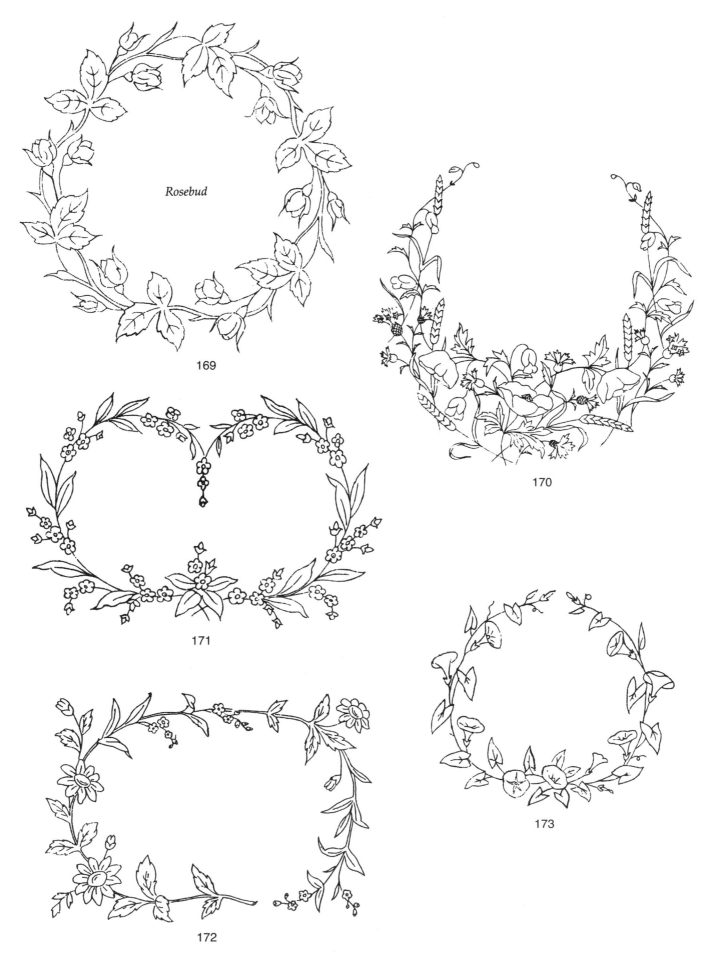

*Rosebud*

169

170

171

172

173

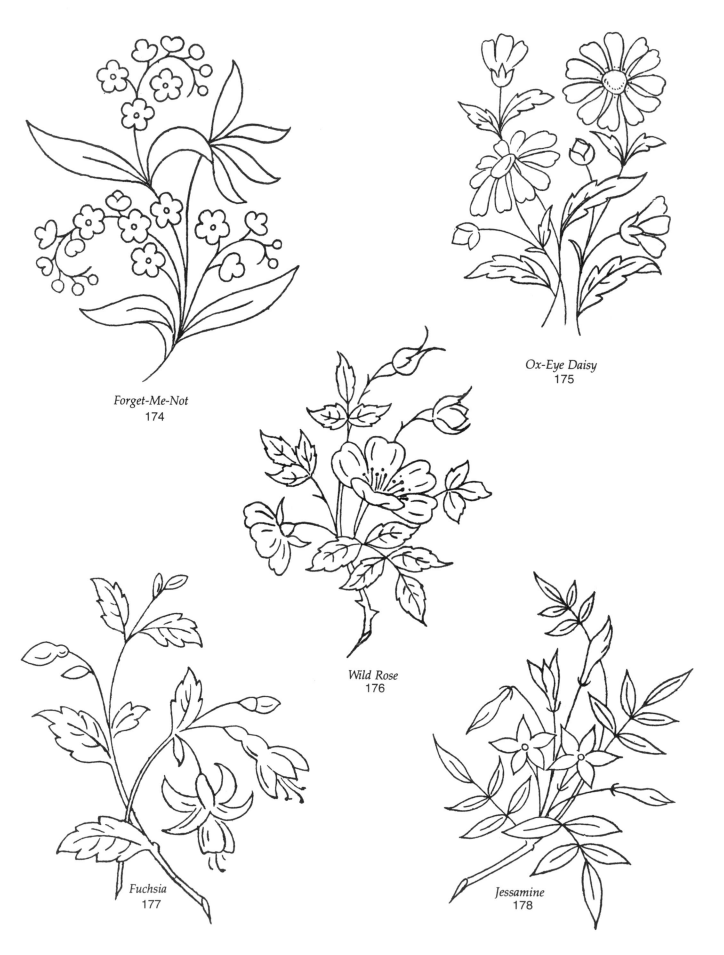

Forget-Me-Not
174

Ox-Eye Daisy
175

Wild Rose
176

Fuchsia
177

Jessamine
178

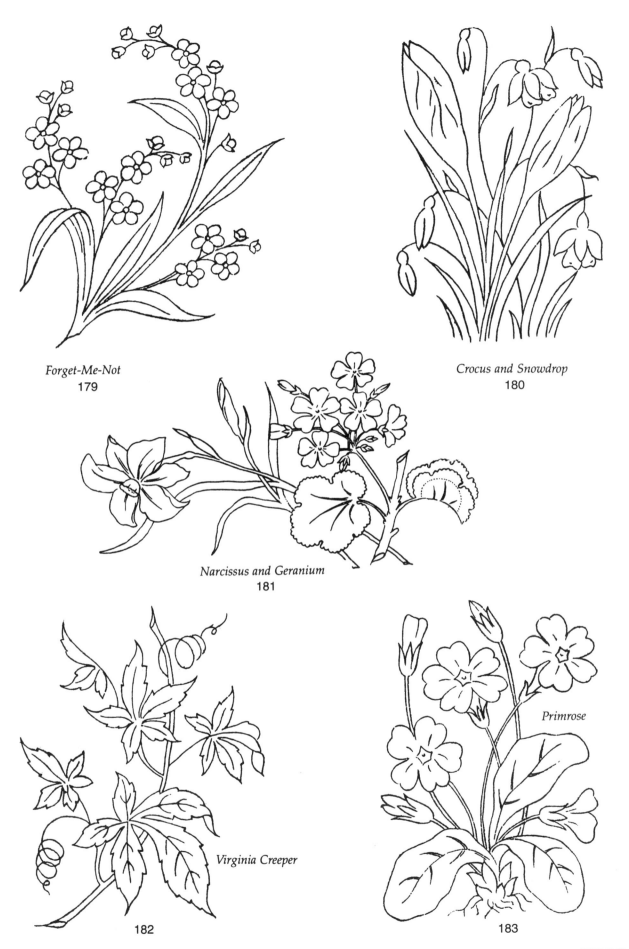

Forget-Me-Not
179

Crocus and Snowdrop
180

Narcissus and Geranium
181

Virginia Creeper
182

Primrose

183

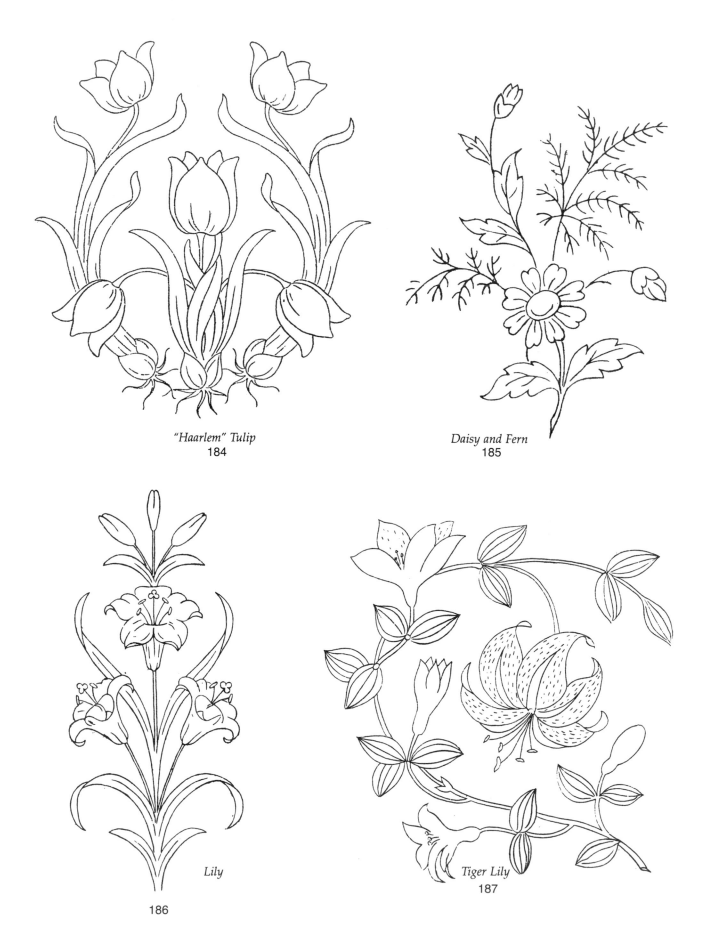

*"Haarlem" Tulip*
184

*Daisy and Fern*
185

*Lily*

186

*Tiger Lily*
187

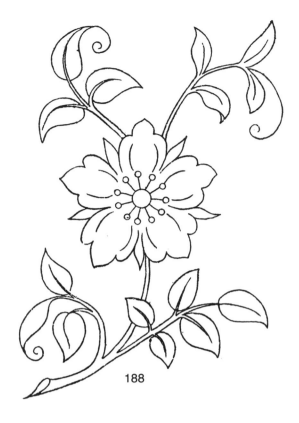

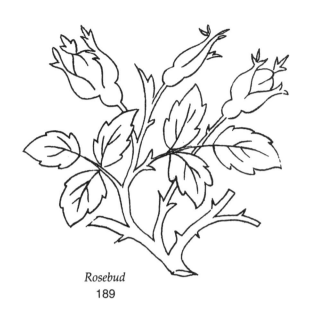

Rosebud
189

188

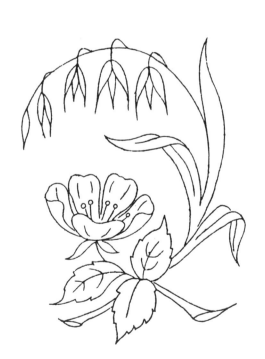

Wild Rose and Oats Grass
190

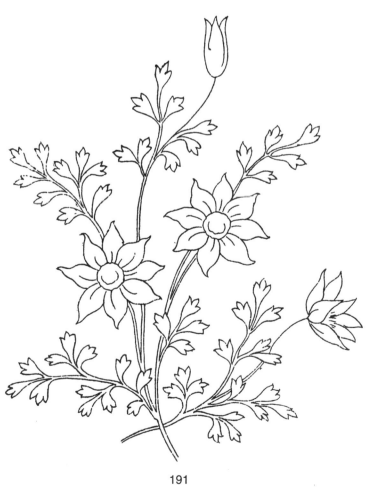

191

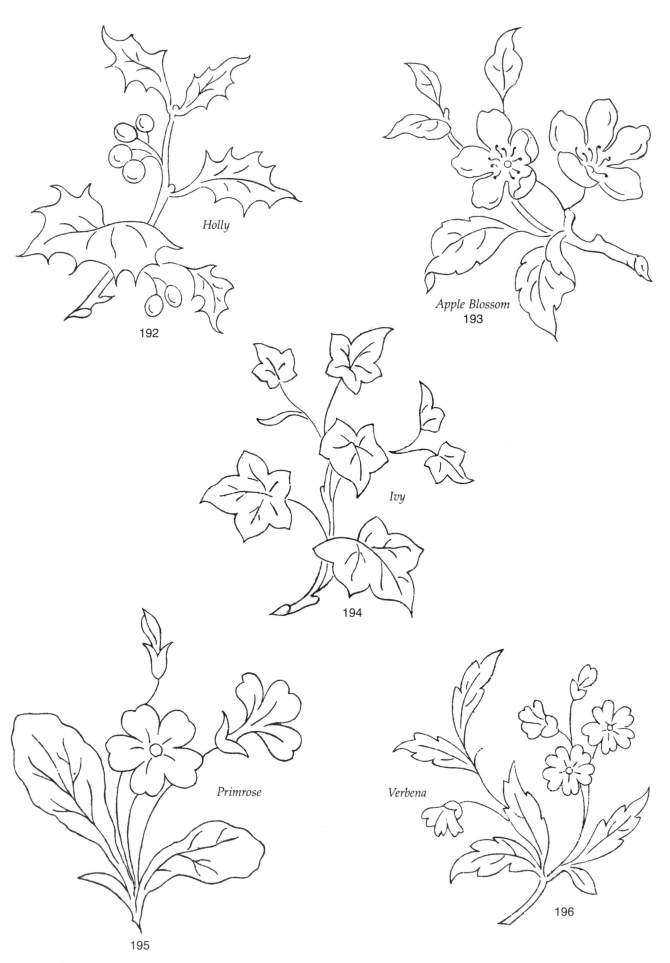

*Holly*

192

*Apple Blossom*
193

*Ivy*

194

*Primrose*

195

*Verbena*

196

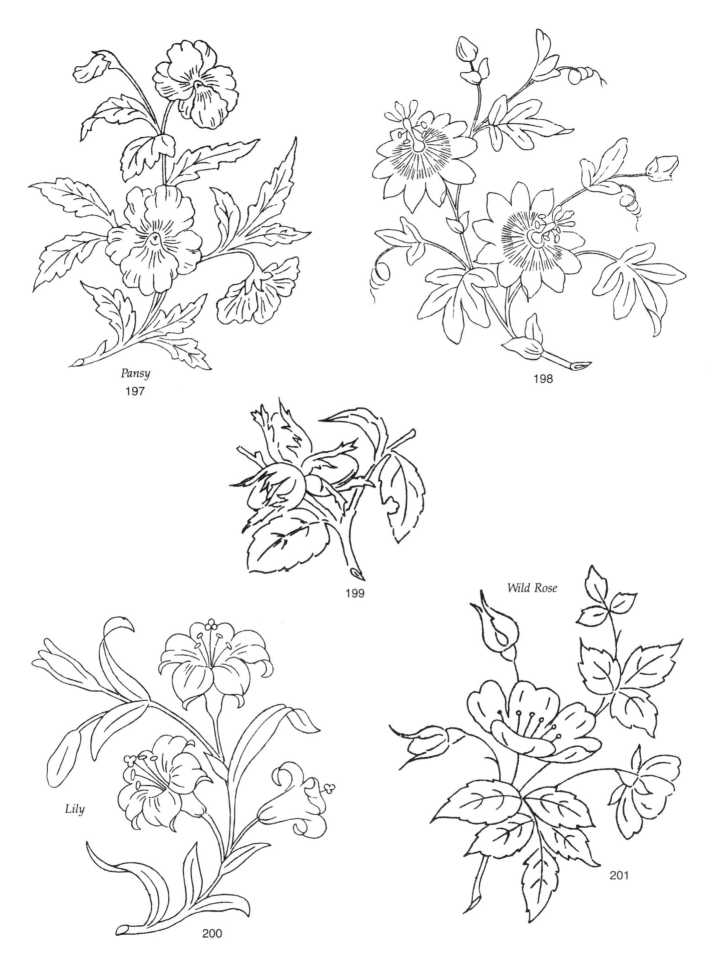

*Pansy*
197

198

199

*Wild Rose*

*Lily*

200

201

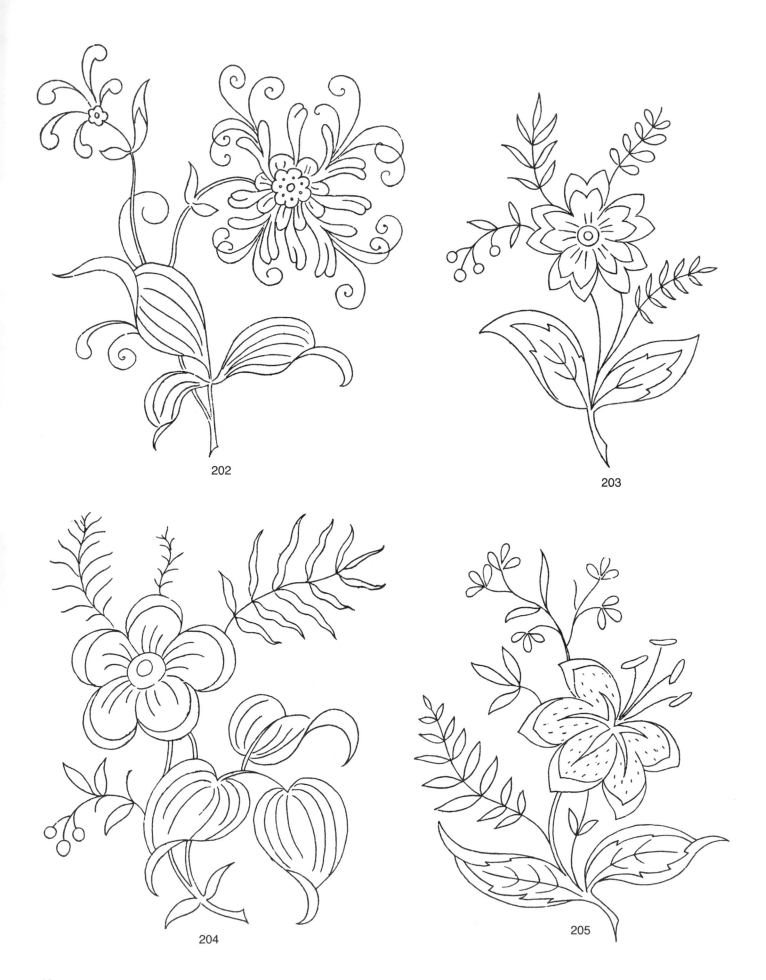

202

203

204

205

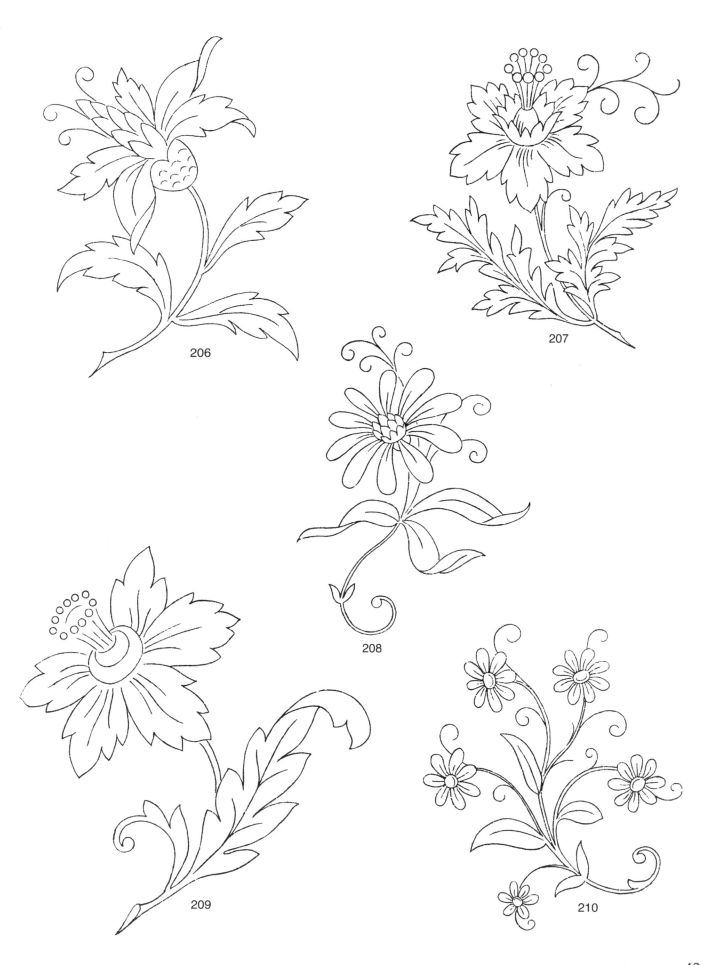

206

207

208

209

210

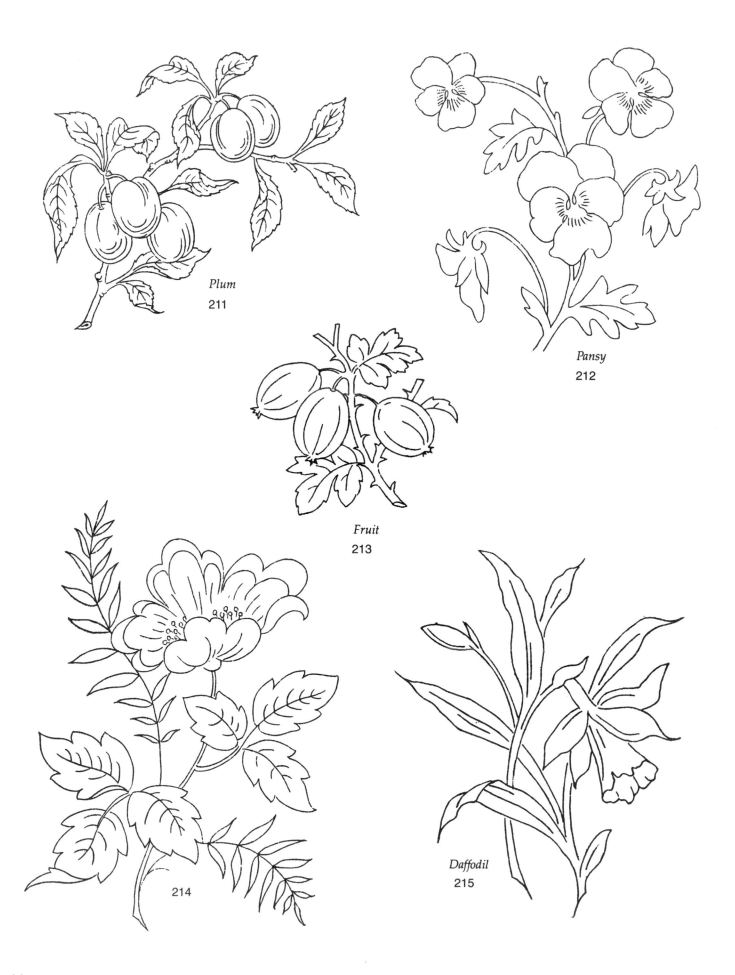

*Plum*
211

*Pansy*
212

*Fruit*
213

214

*Daffodil*
215

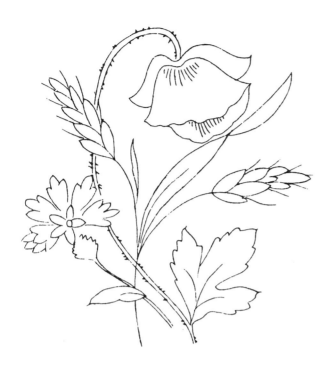

*Poppy, Wheat and Cornflower*

216

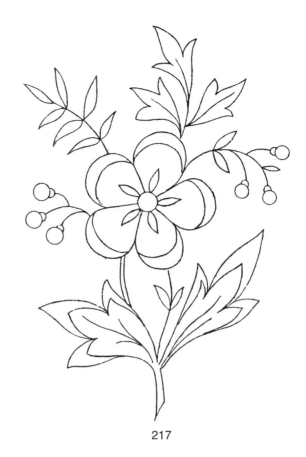

217

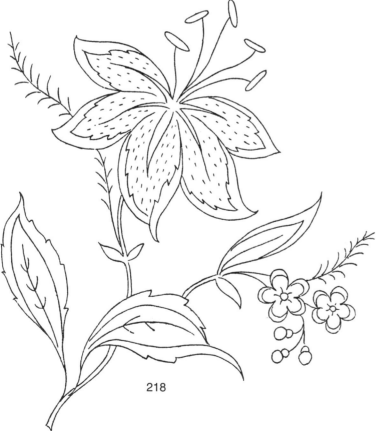

218

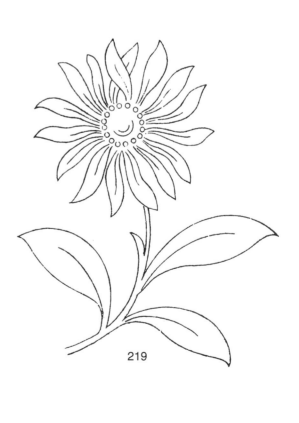

219

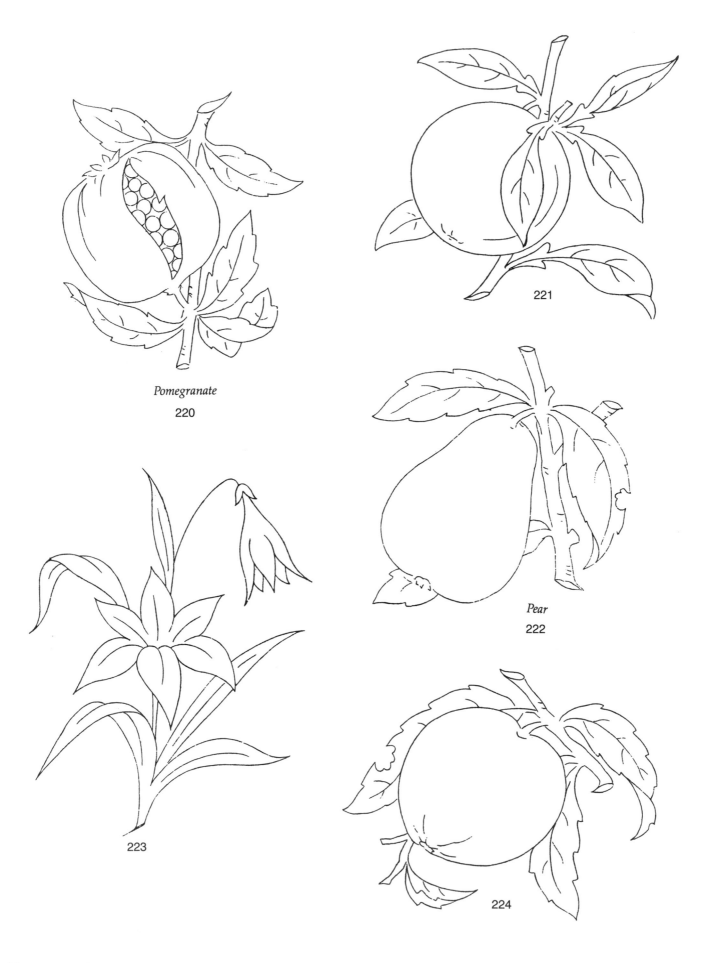

Pomegranate
220

221

*Pear*
222

223

224

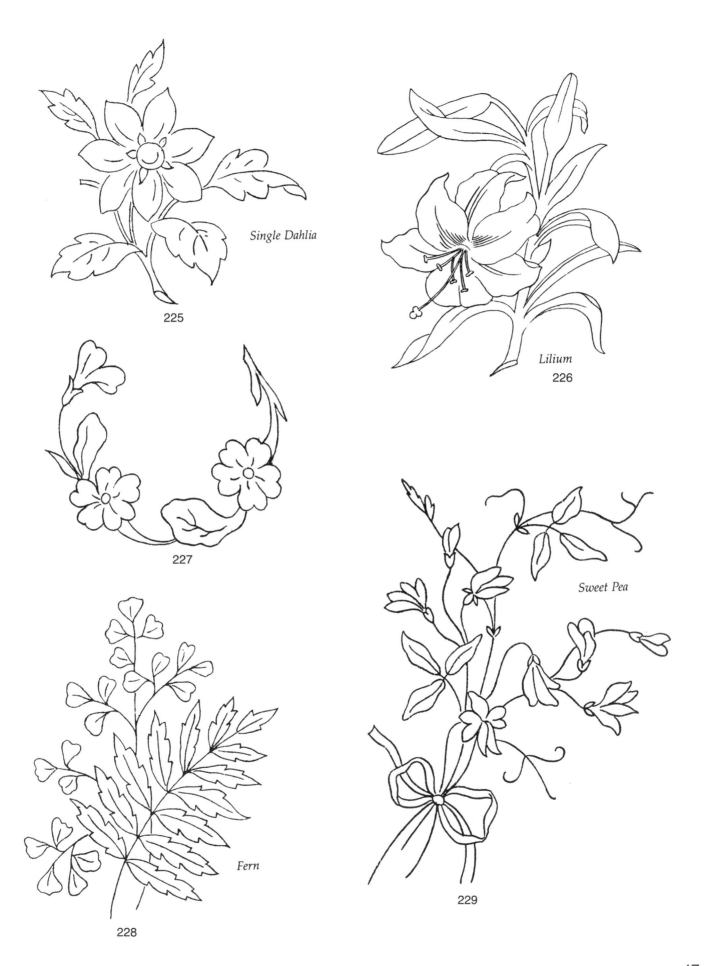

Single Dahlia

225

Lilium
226

227

Sweet Pea

Fern

228

229

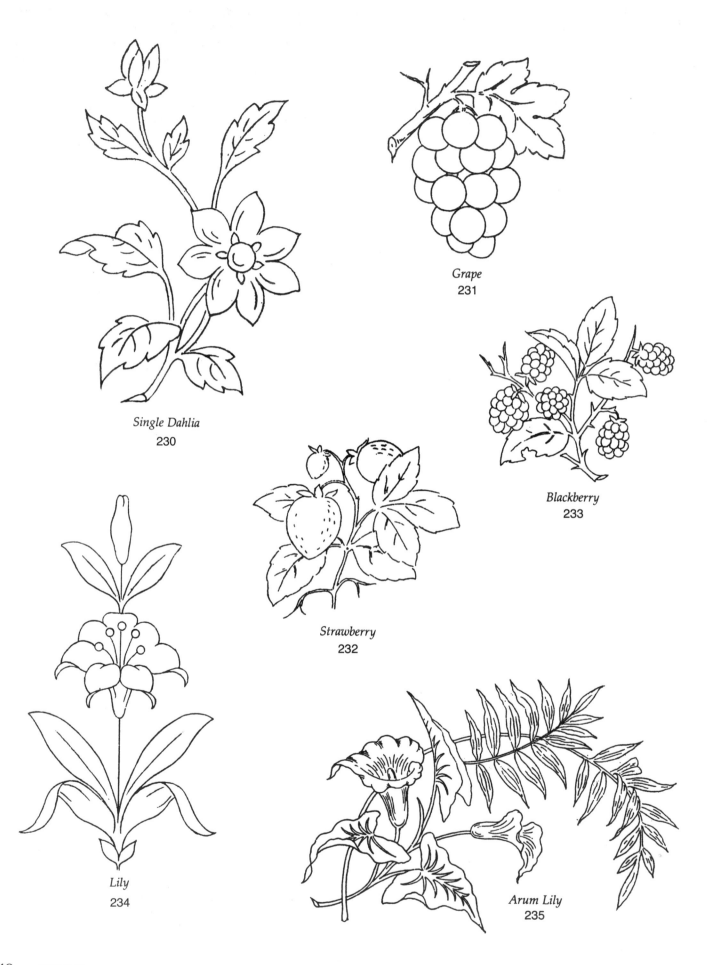

Grape
231

Single Dahlia
230

Blackberry
233

Strawberry
232

Lily
234

Arum Lily
235